Word Salad, Fashionistas and Girlfriends

Cartoon Stories + Fashion + Quilting

ISBN: 978-0-578-96800-1

Quilts by Kathryn Alison Pellman

All photos except as noted by Johanna Love
Author photo by Danita Rafalovich
A Fashionista and Her Garden photo by Barbara Hollinger
Save the Date by Wayne Smith
Grandmother photos unknown
Princess Liza Chihuahua and Petunia Olive by author

Book Design by Lissa Auciello-Brogan

Cover Photo: Dear Stella (8″ x 8″)
Facing page: Astrid Presents Girls Night Out (8″ x 8″)

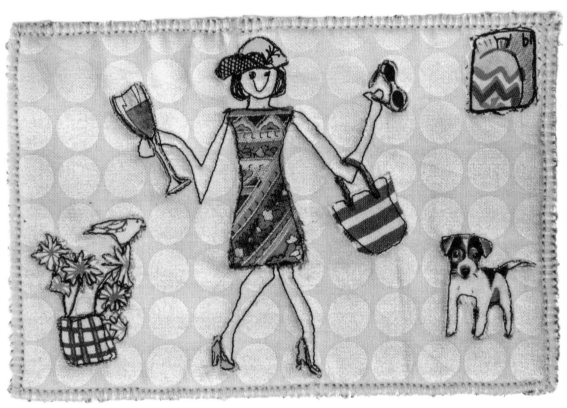

Fashionista Wine Tasting 4″ x 6″

Word Salad, Fashionistas and Girlfriends

Cartoon Stories + Fashion + Quilting

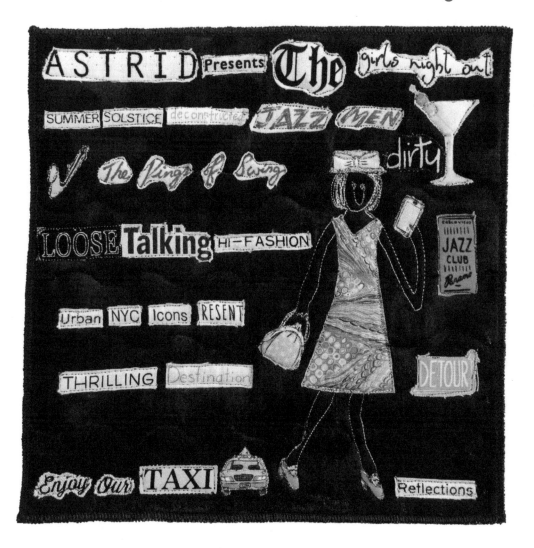

Kathryn Alison Pellman

For my grandmother, Shirley Rivlin Pellman, who gave me unconditional love, and in whose kitchen the Cinderella bowl spoke, telling me "good girl" after I finished my bowl of Farina.

And for my grandmother, Augusta Wells Fleischer, whose meticulously cut and collaged books of 1930s advertisements made for each of her four daughters continue to inspire me.

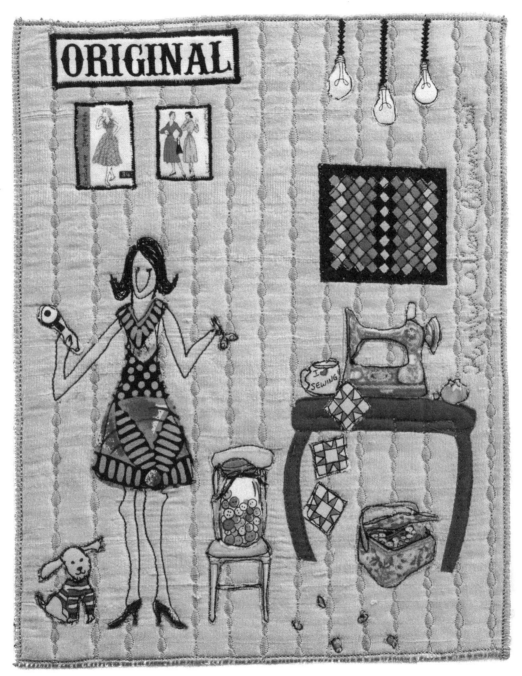

Original Studio Fashionista 10" x 8"

Contents

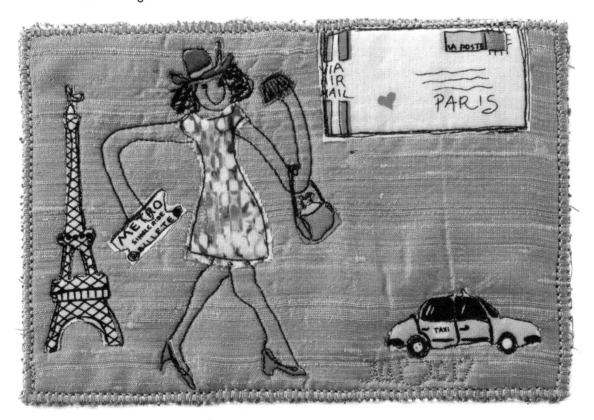

A Fashionista In Paris

4" x 6"

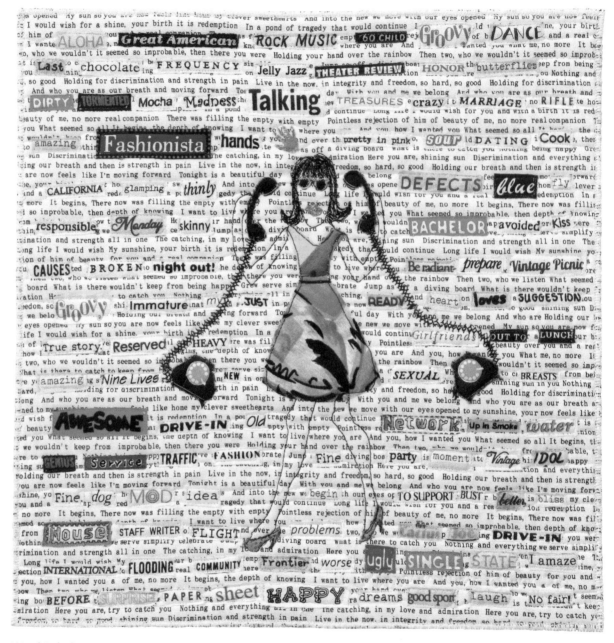

Word Salad

12" x 12"

What Is Word Salad?

Word Salad is a type of found poem and literary collage. As with my Fashionista quilts, I create word salad quilts by cutting up fun, conversational prints from multiple fabric lines. As I cut words and phrases from the fabric, I toss them around on my cutting table, making a "word salad." Sometimes the words arrange themselves, revealing a theme for the poem, while at other times I pick the words and phrases that speak to me. Either way, I never know in advance what story they will tell until the collage of words emerges in poem order.

Much like a tossed salad — where I never know in advance how the flavors of the vegetables, fruits, greens, and dressing will meld and play off each other — I never know what my poetry quilt is about until the fabric words are arranged, rearranged, added, taken away, and mixed with the fabric images. The Word Salad poem is always a surprise to me.

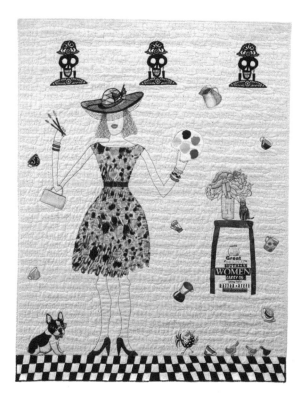

Resist Persist Create

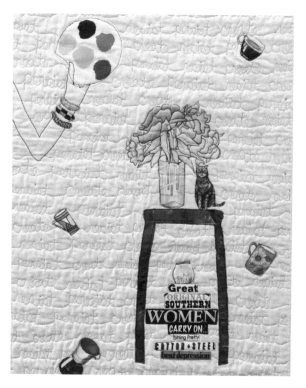

41" x 32"

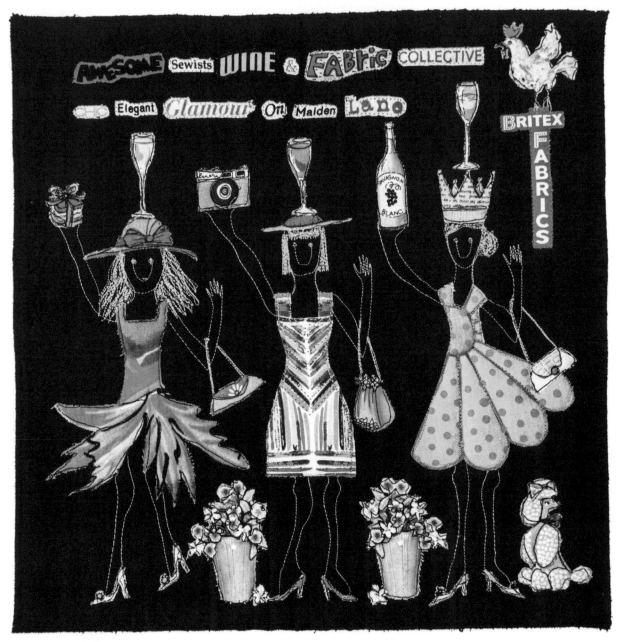

Awesome Sewists Wine & Fabric Collective

12" x 12"

What Is a Fashionista?

A Fashionista is commonly defined as a devoted follower of fashion, although not necessarily someone who follows trends.

My idea of a Fashionista is someone who approaches getting dressed as an art form. She is stylish, and expresses herself artfully through her clothes and accessories. Her body is a canvas that expresses her creativity.

My Fashionistas are strong, independent, original, confident, and powerful women. They combine femininity and feminism with a splash of humor, and even a bit of drama from time to time as they enjoy life, friendships, and romance, both real and imagined.

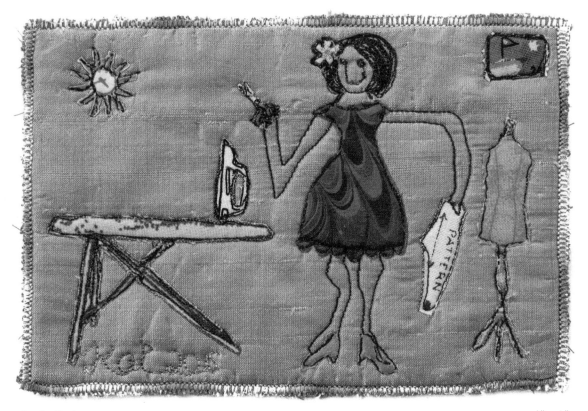

Studio Fashionista 4" x 6"

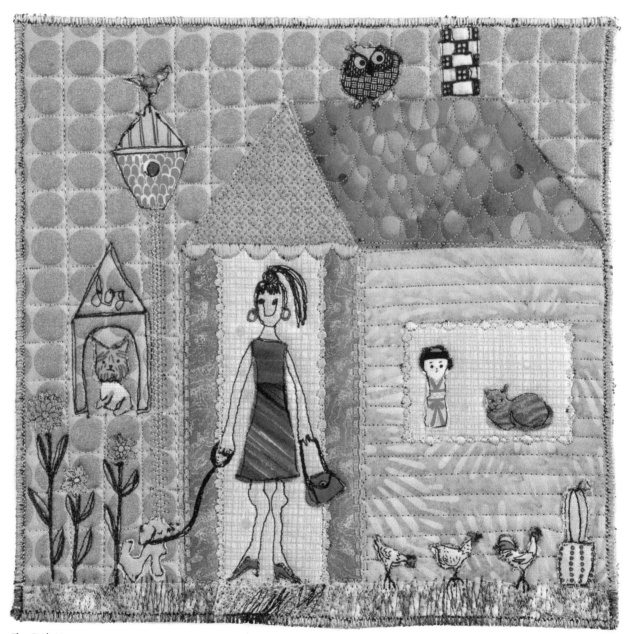

The Pink House

8" x 8"

Meet the Fashionistas

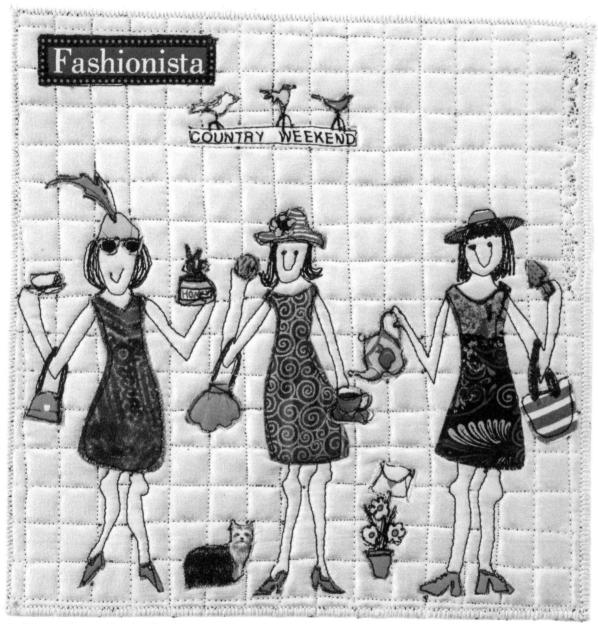

Fashionista Country Weekend

8" x 8"

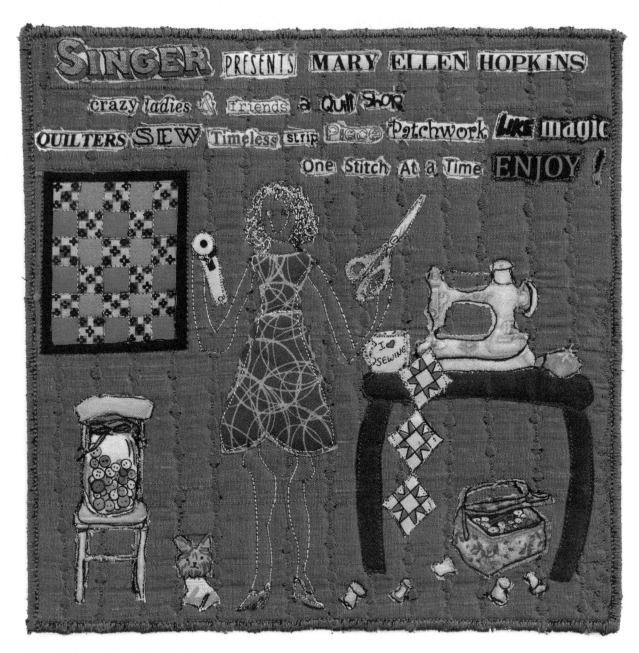

Singer Presents Mary Ellen Hopkins

8" x 8"

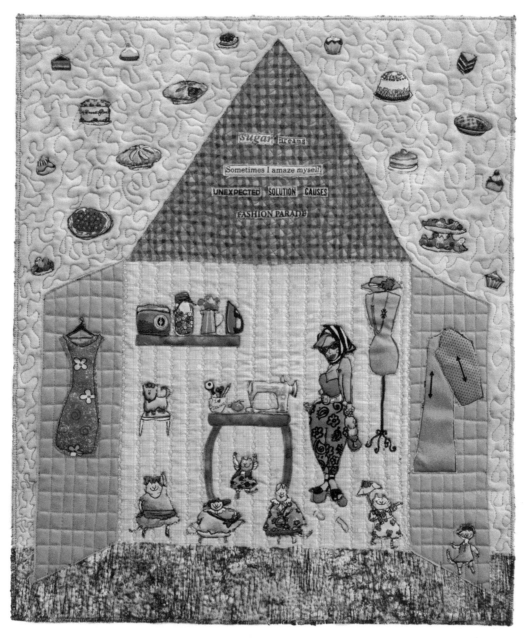

Sugar Dreams 20" x 17"

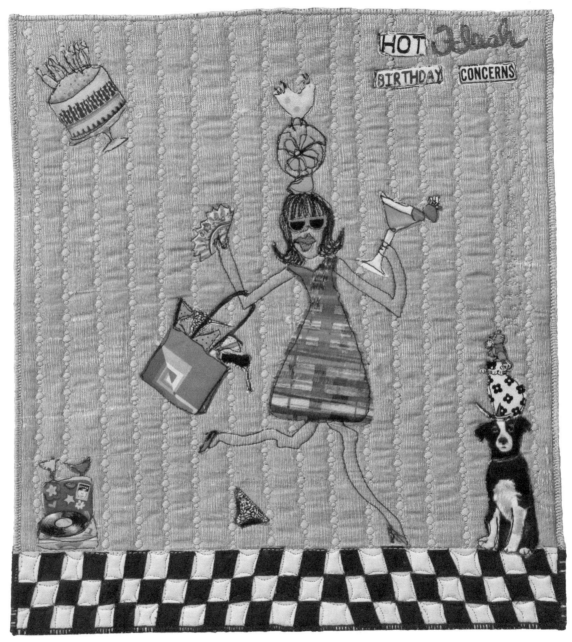

Hot Flash Birthday Concerns

12" x 12"

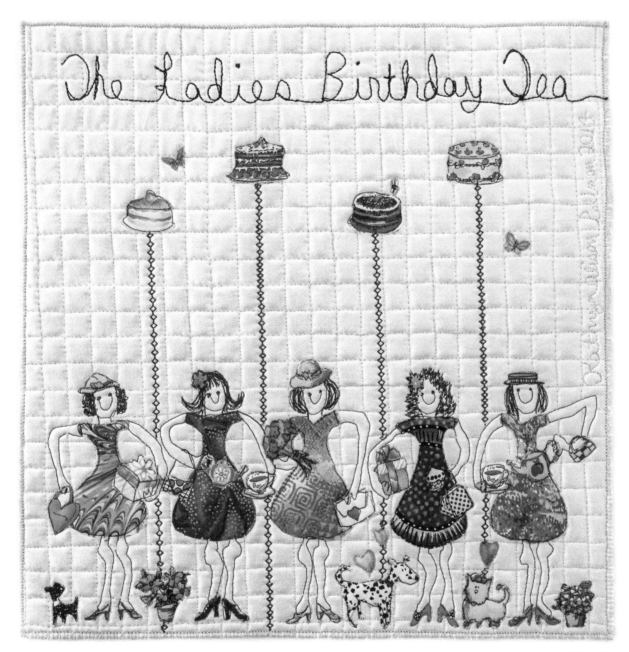

The Ladies Birthday Tea 12" x 12"

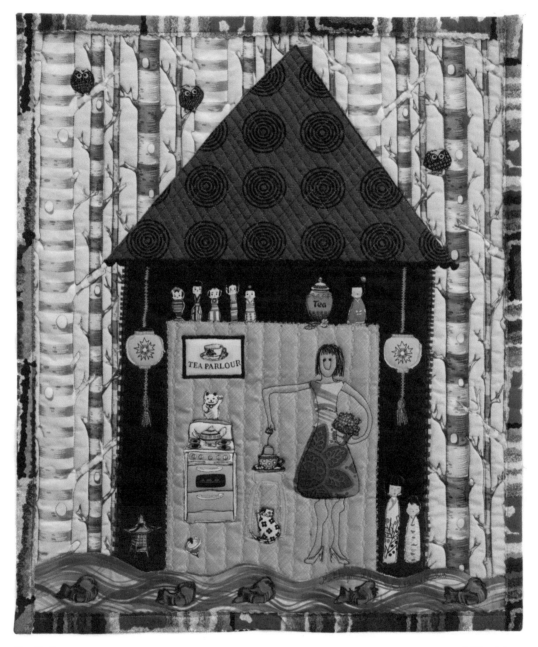

Tea Parlor

20" x 16.5"

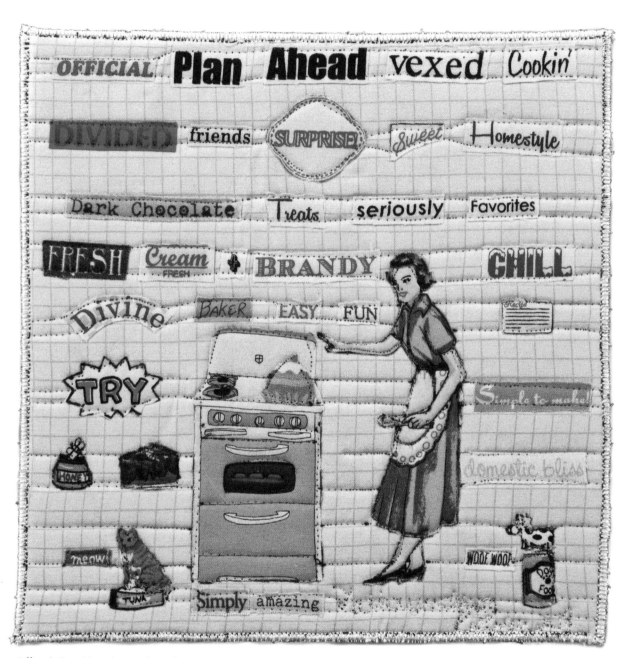

Official Plan Ahead Vexed Cookin' 8" x 8"

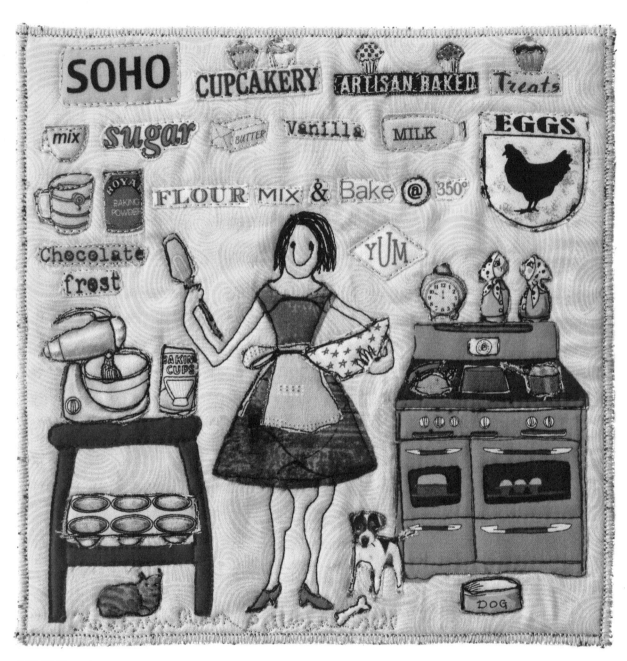

SOHO Cupcakery

8" x 8"

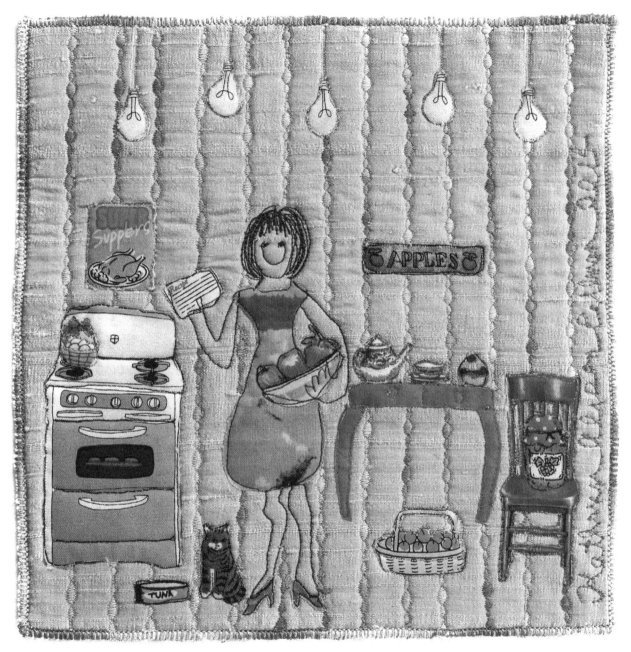

Apple Pie

8″ x 8″

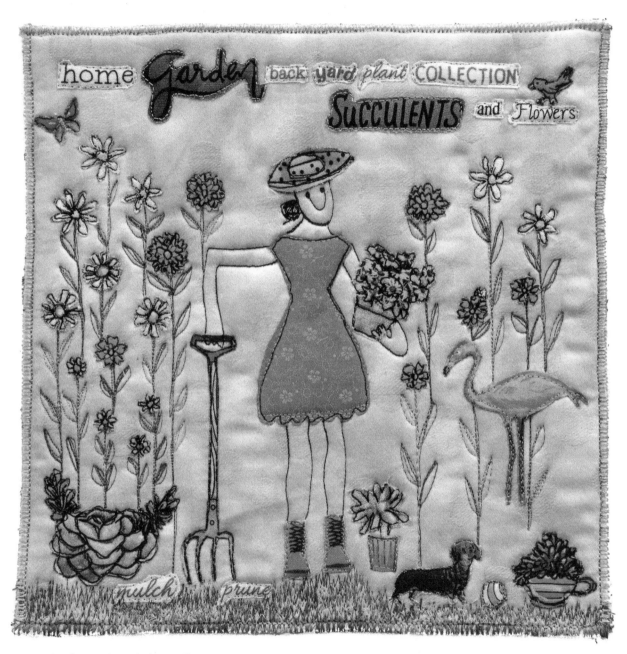

Home Garden Back Yard Plant Collection

8" x 8"

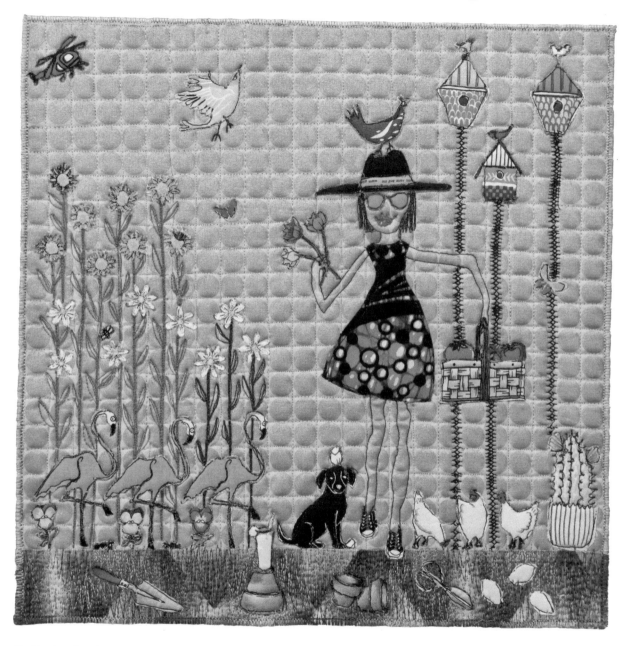

Fashionista Gardener

12" x 12"

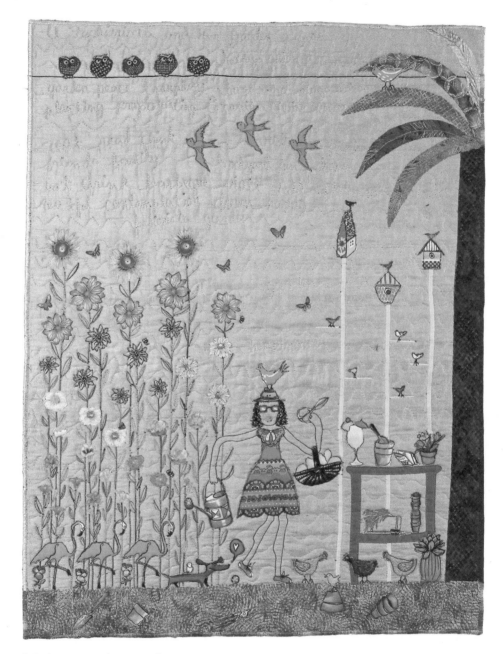

A Fashionista and Her Garden 24" x 18"

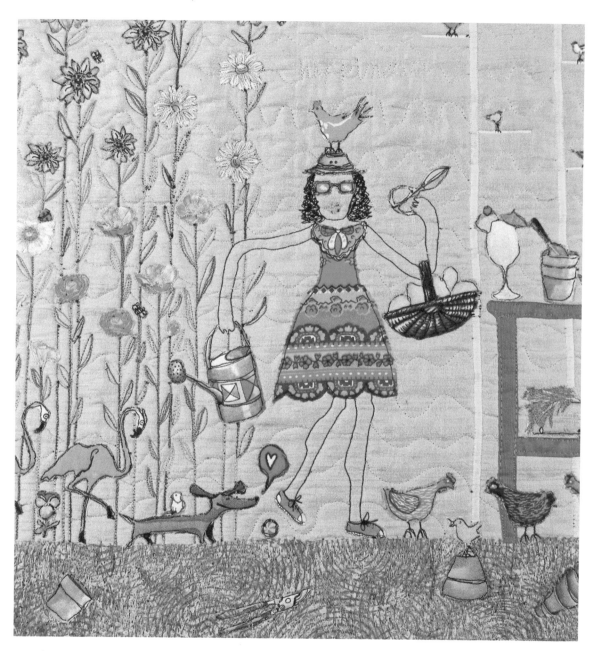

A Fashionista and Her Garden (detail)

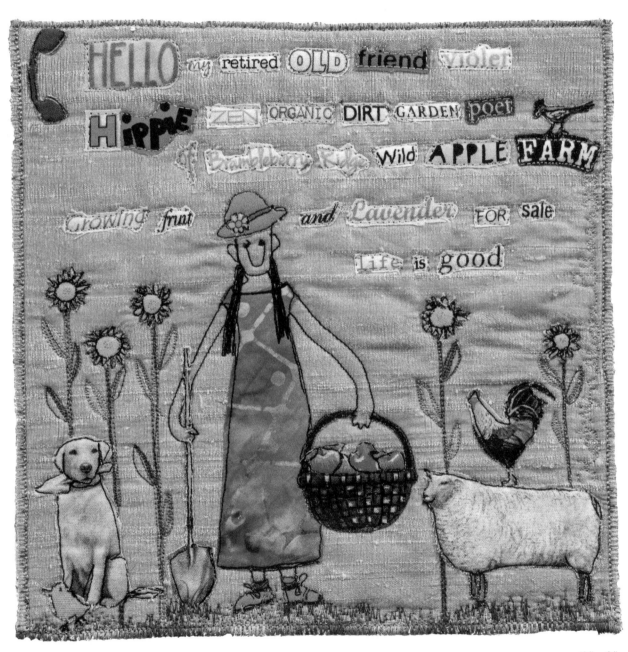

Hello My Retired Old Friend Violet

8" x 8"

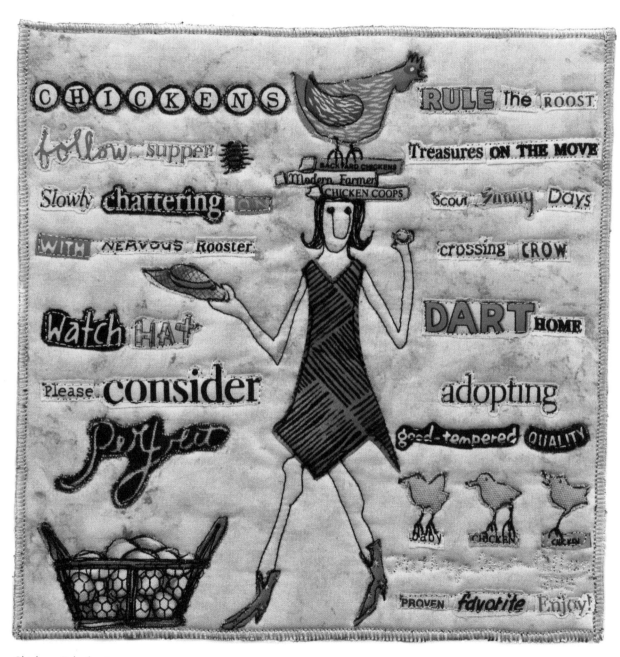

Chickens Rule the Roost

8" x 8"

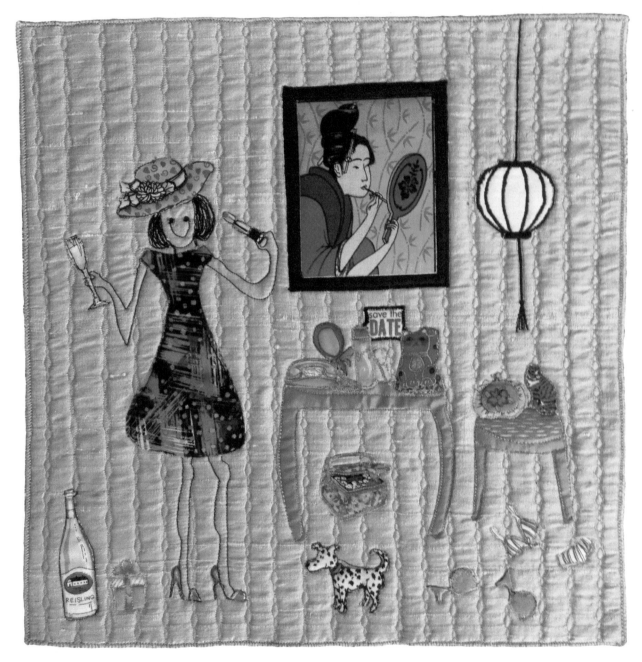

Save the Date

12″ x 12″

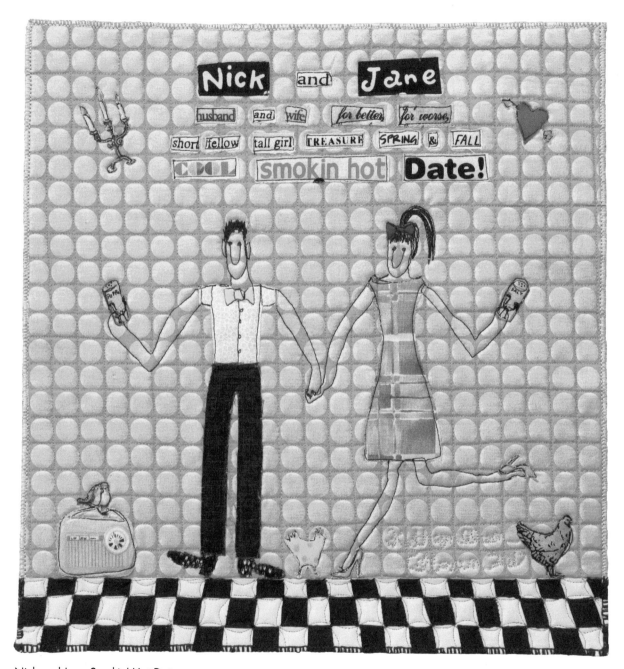

Nick and Jane Smokin' Hot Date

12" x 12"

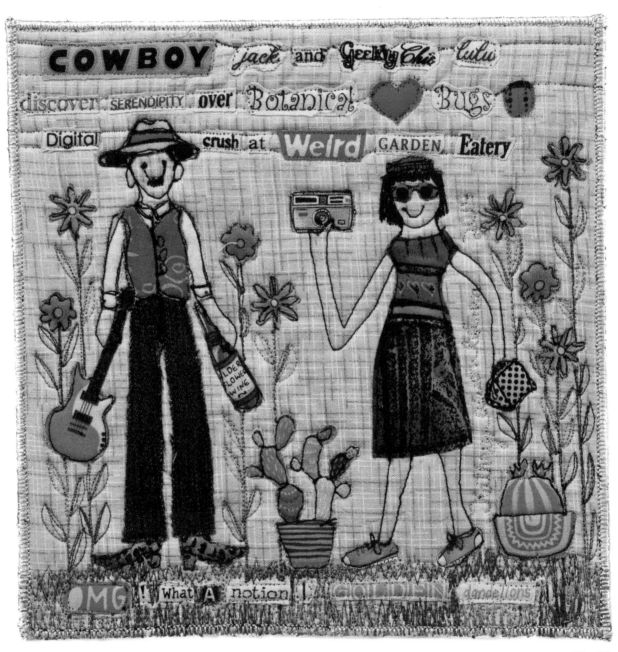

Cowboy Jack and Geeky Chic Lulu

8" x 8"

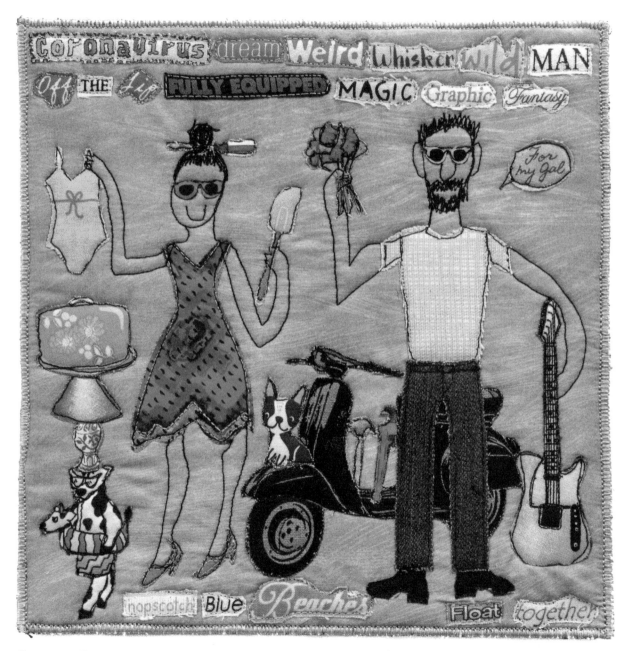

Coronavirus Dreams

8" x 8"

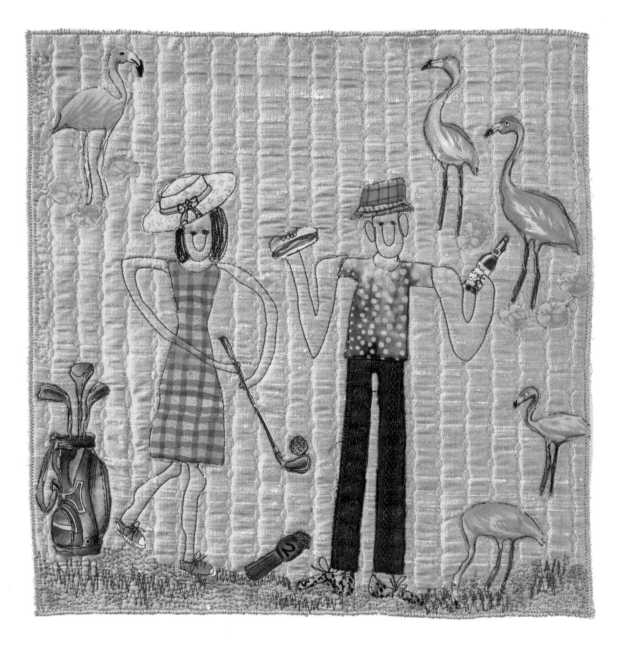

Pink Flamingo Golf 12" x 12"

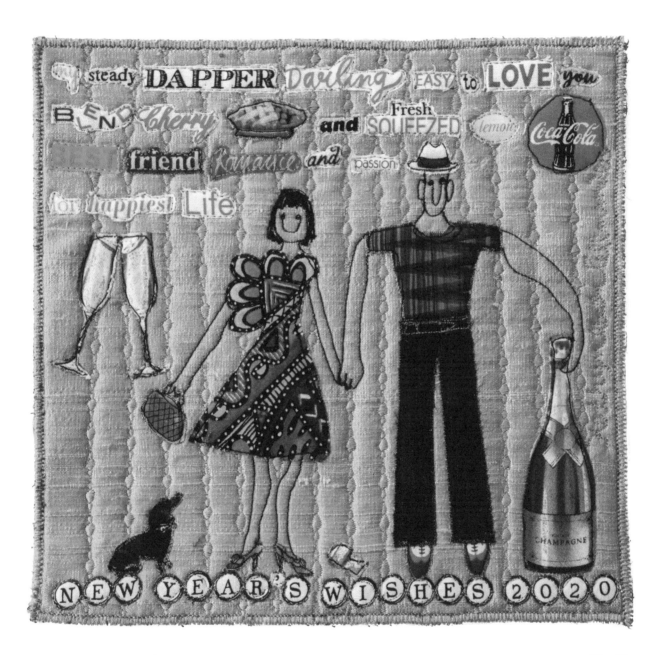

My Steady Dapper Darling

8″ x 8″

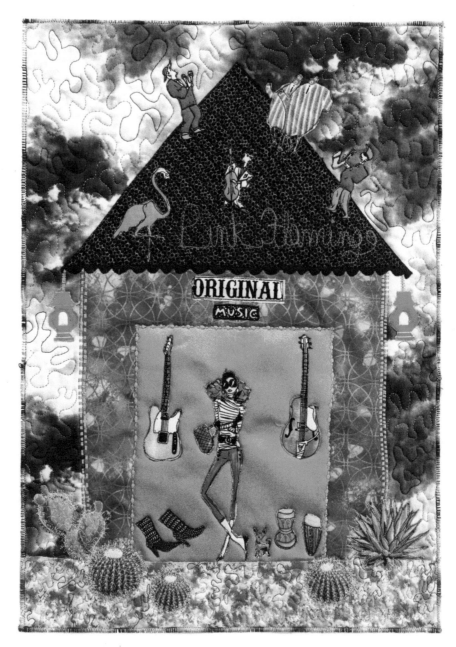

Pink Flamingo Original Music 17" x 12"

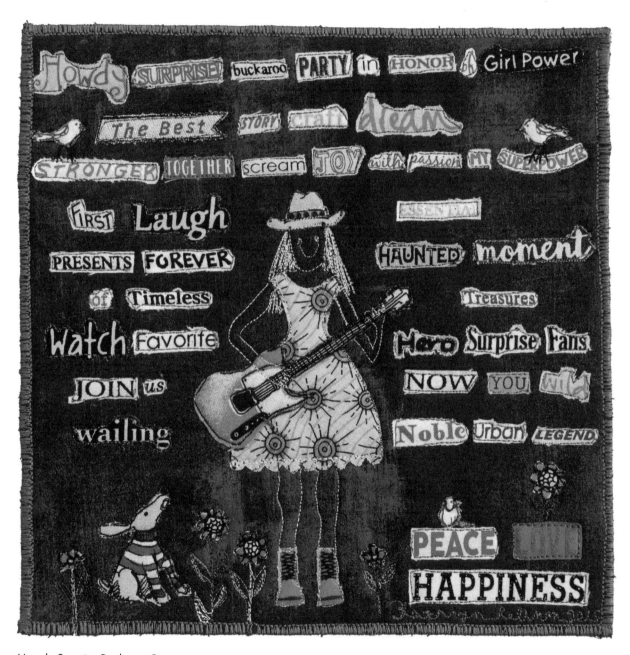

Howdy Surprise Buckaroo Party

8″ x 8″

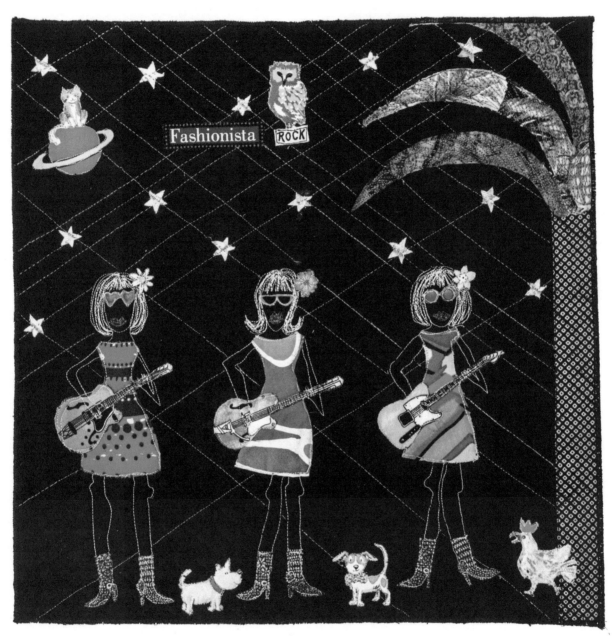

Fashionista Rock, a Girl Group

14" x 14"

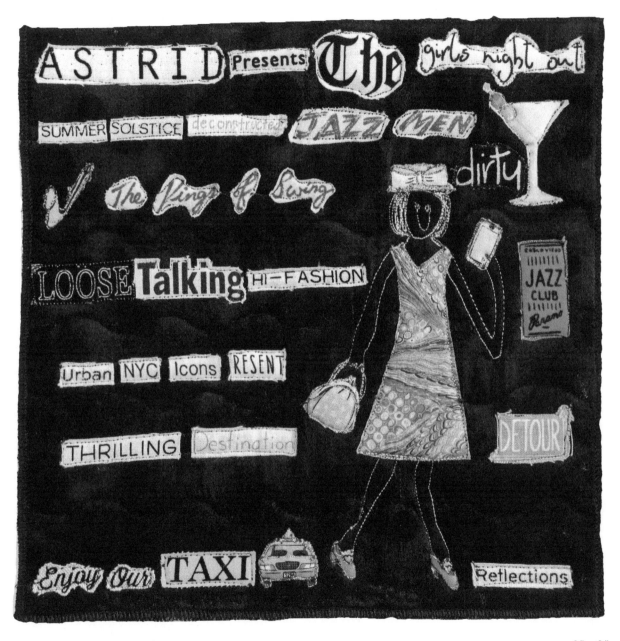

Astrid Presents the Girls Night Out

8" x 8"

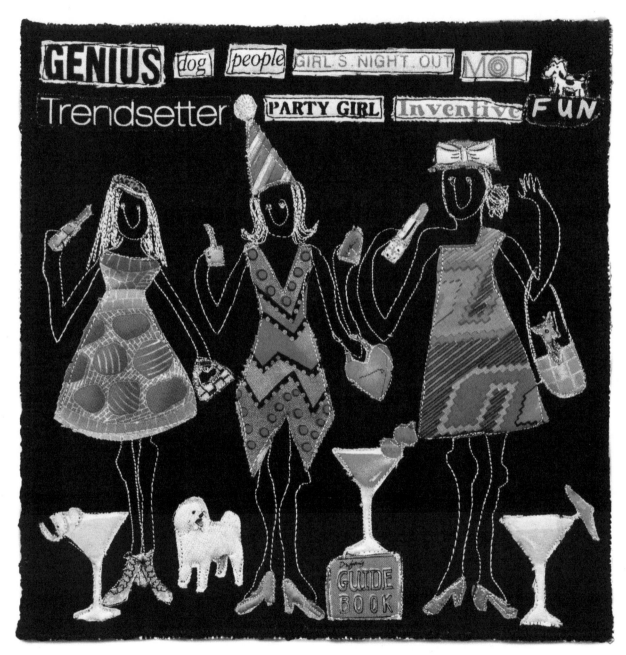

Genius Dog People

8" x 8"

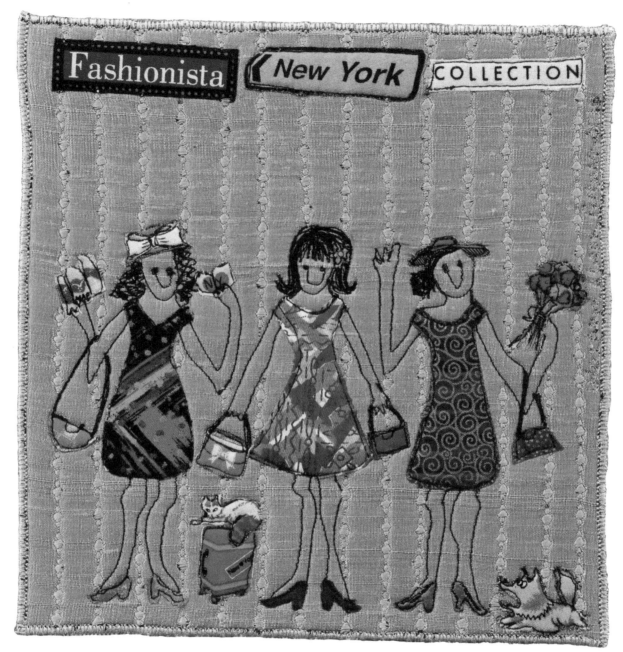

Fashionista New York Collection

8" x 8"

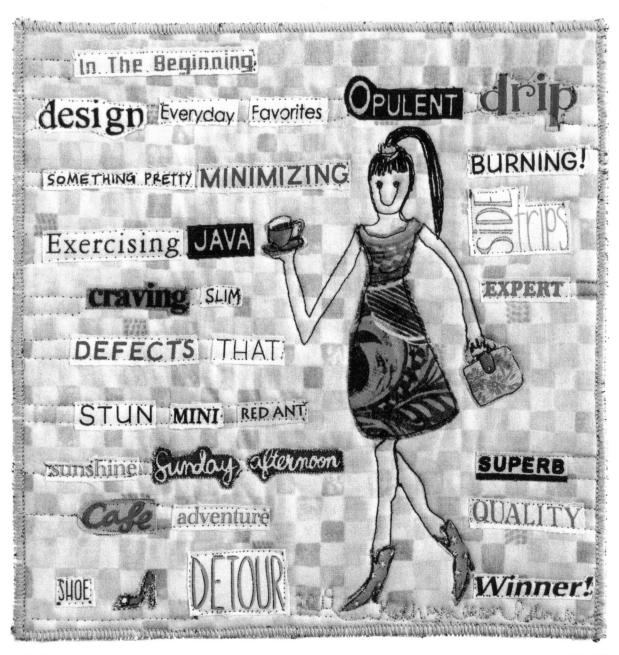

In the Beginning

8" x 8"

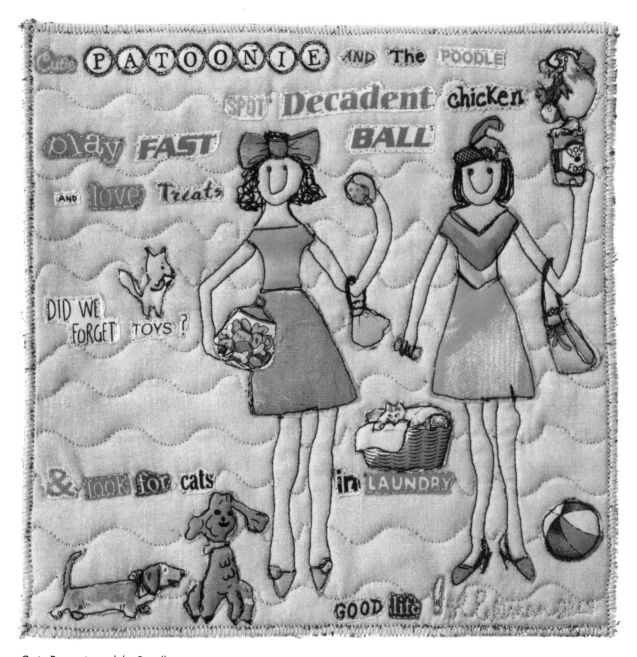

Cutie Patoonie and the Poodle

8" x 8"

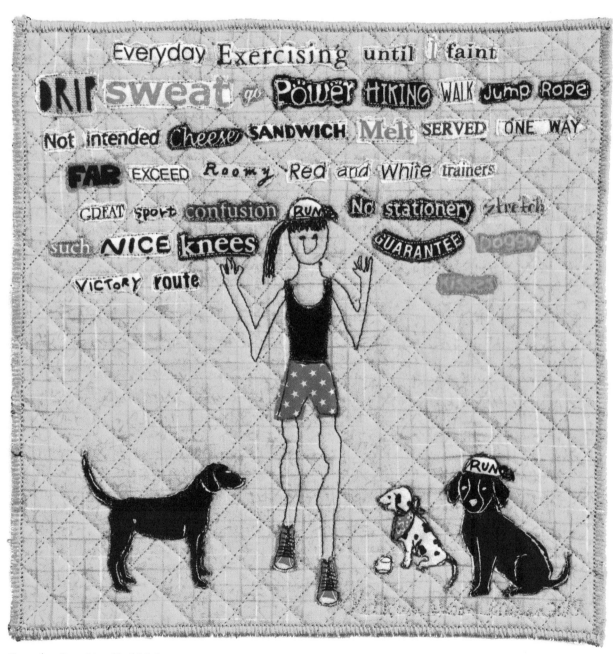

Everyday Exercising Until I Faint

8" x 8"

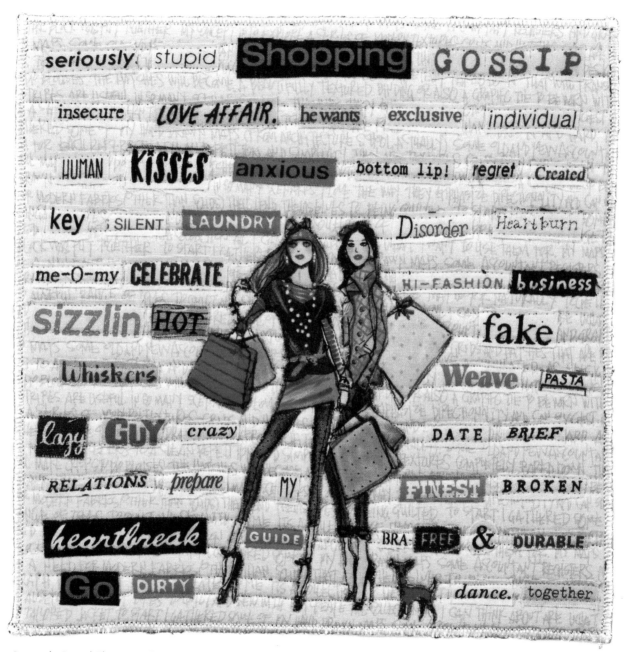

Seriously Stupid Shopping Gossip

8" x 8"

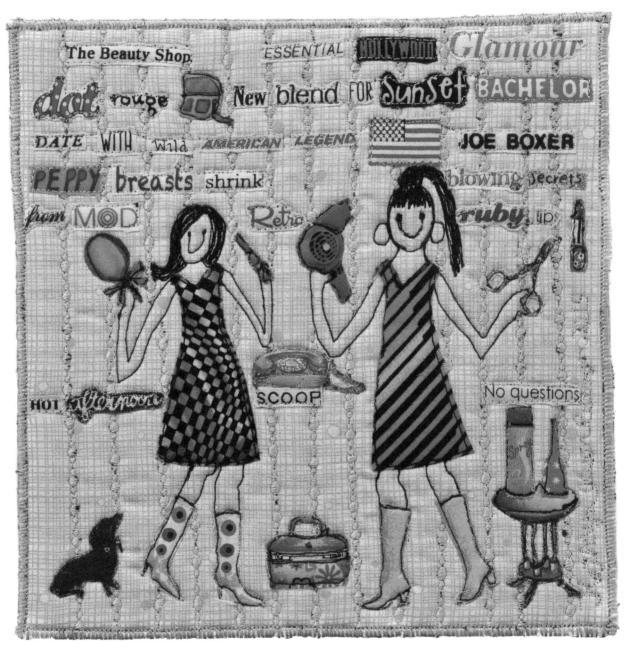

The Beauty Shop

8" x 8"

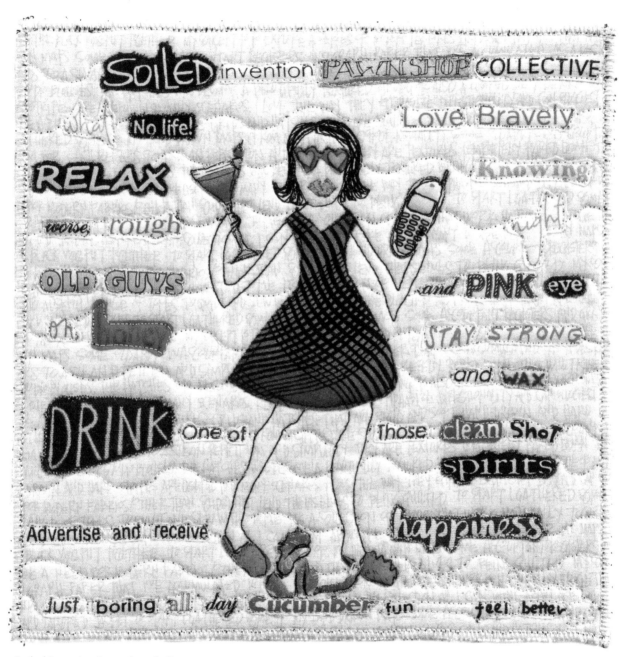

Soiled Invention Pawnshop Collective

8" x 8"

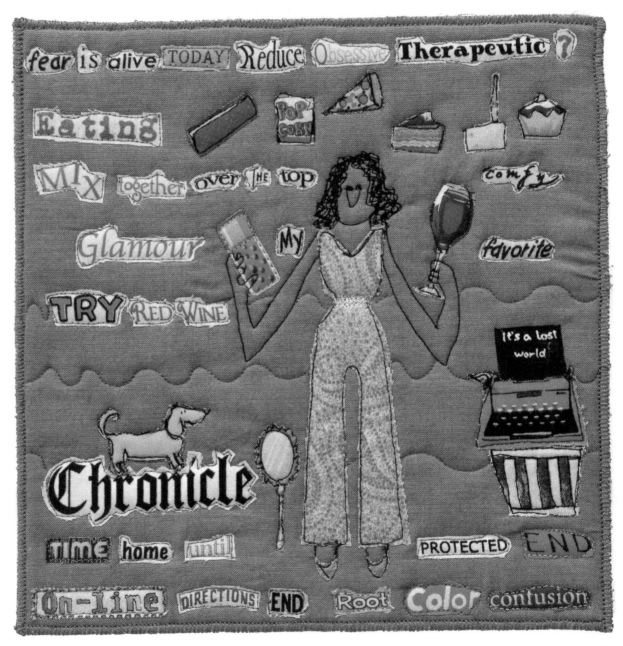

Fear Is Alive Today

8" x 8"

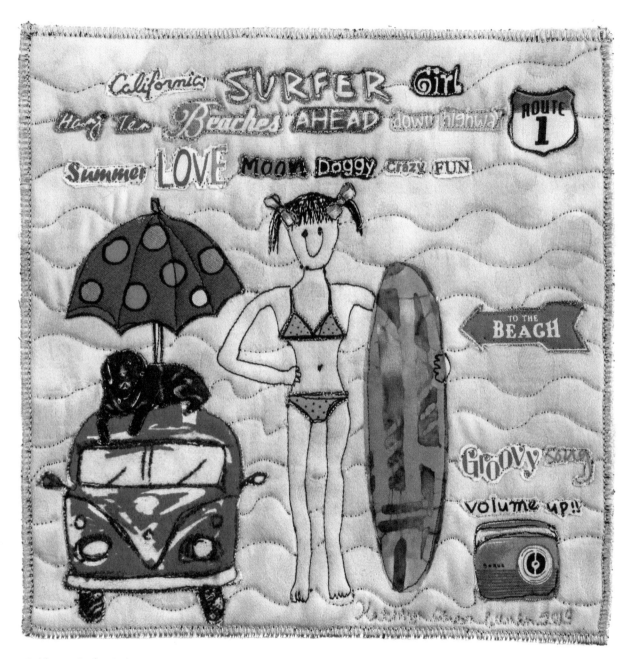

California Surfer Girl

8" x 8"

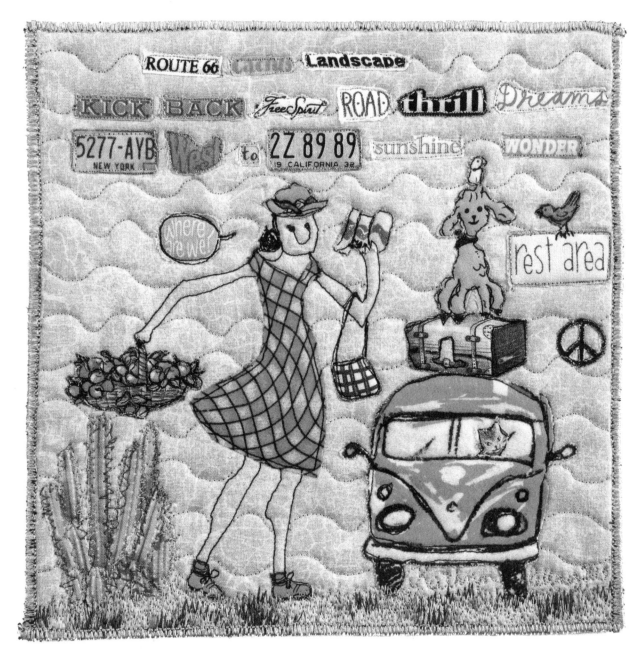

Route 66 Cactus Landscape

8" x 8"

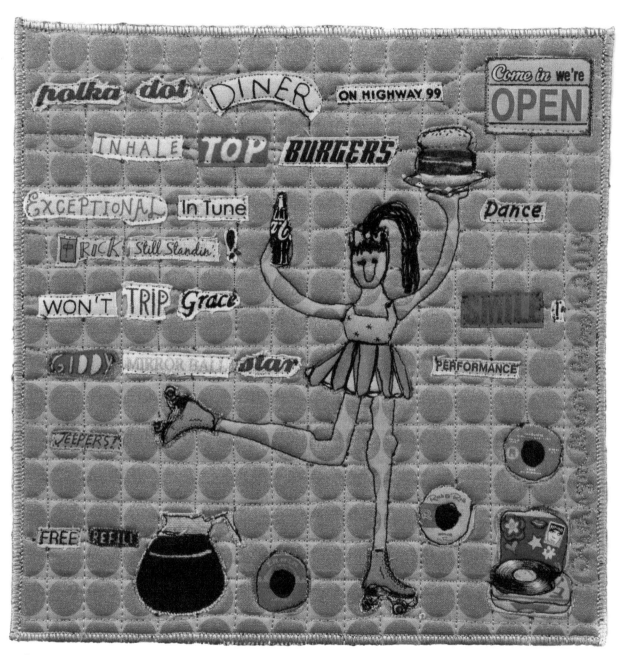

Polka Dot Diner On Highway 99

8" x 8"

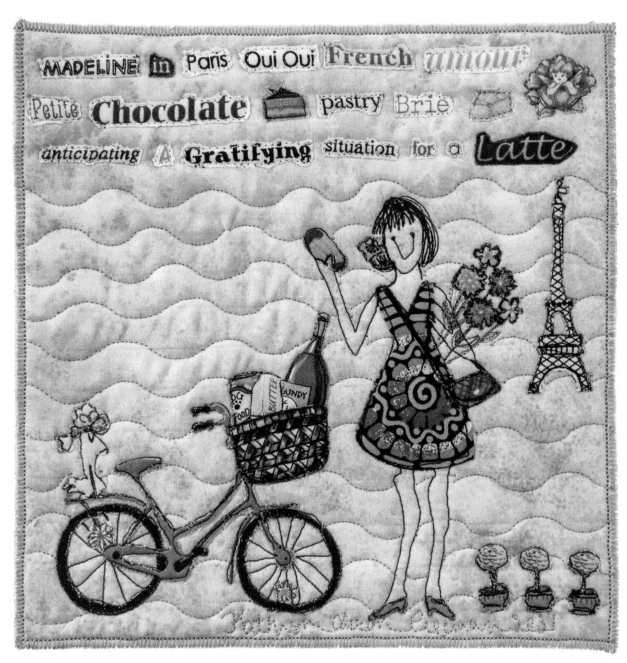

Madeline In Paris

8" x 8"

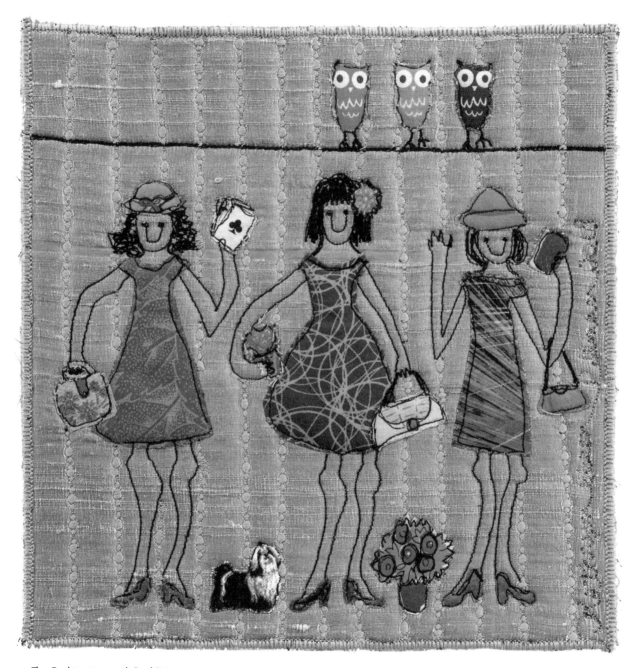

The Fashionista and Owl Trio

8" x 8"

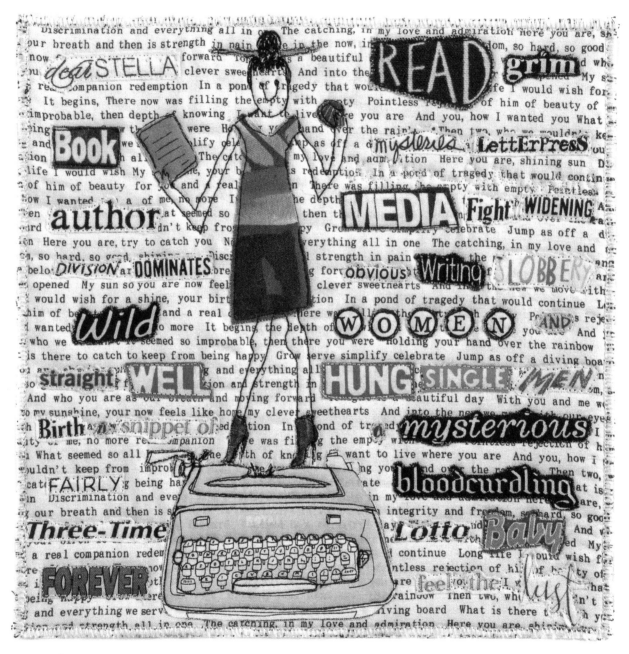

Dear Stella Read Grim Book

8" x 8"

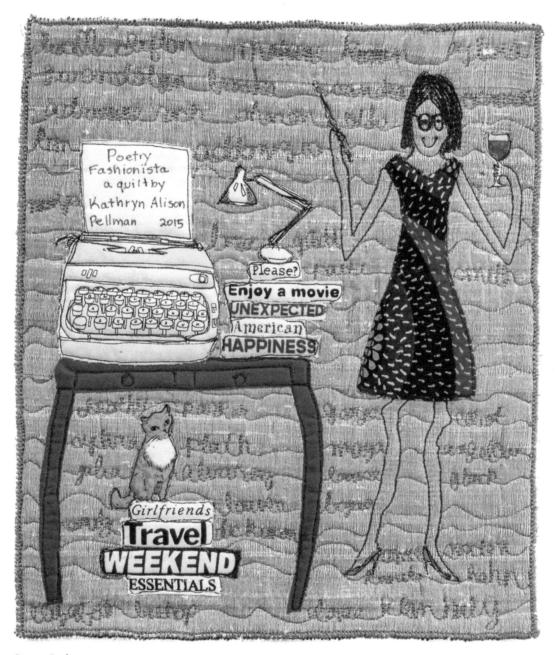

Poetry Fashionista

10" x 8.5"

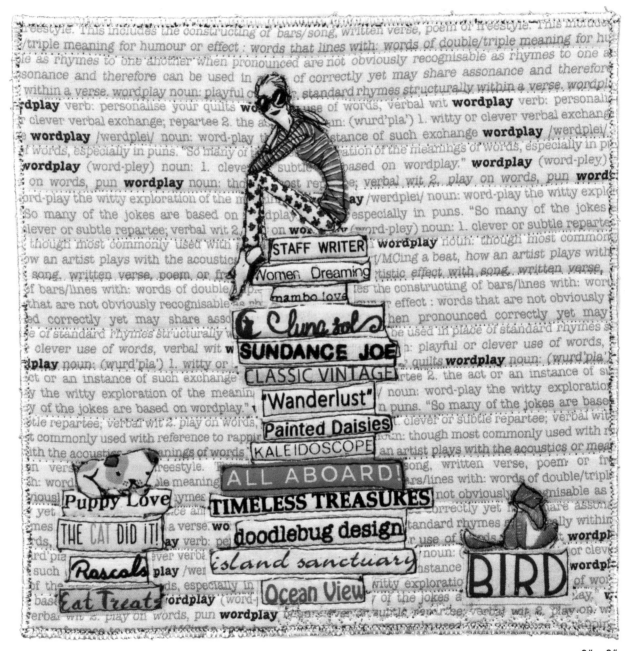

Wordplay

8″ x 8″

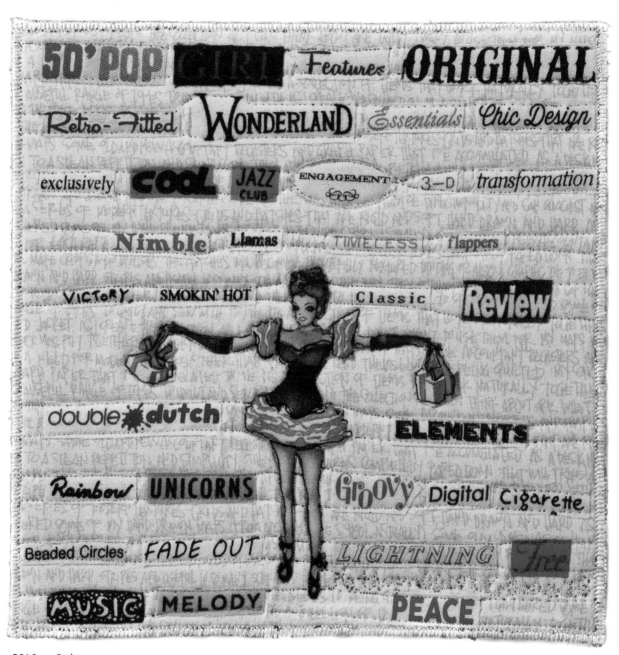

50' Pop Girl

8" x 8"

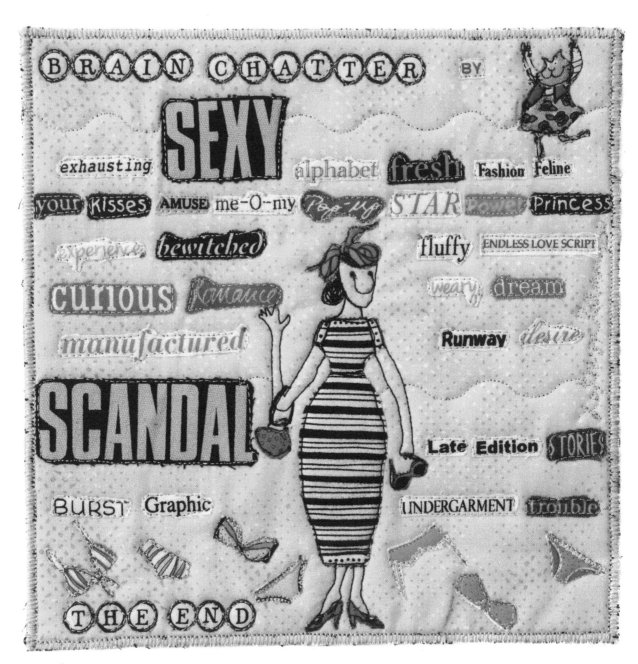

Brain Chatter

8" x 8"

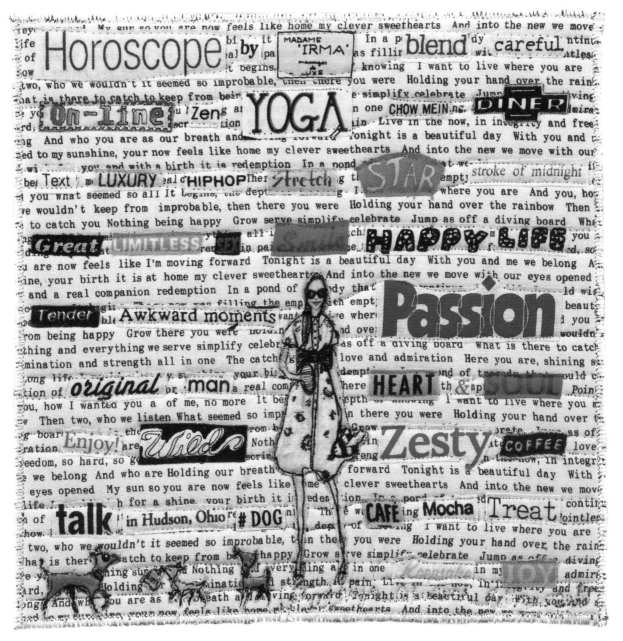

Horoscope by Madame Irma

8" x 8"

About the Author

Kathryn Pellman is a Los Angeles artist, fashionista, quilter, cook, baker, gardener, and storyteller. Her whimsical series of small, playful, single-frame cartoons feature long limbed and knobby kneed Fashionistas that invoke fashion illustration. Kathryn's Fasionistas and Word Salad poems combine her passion for quilting and fashion, and invite women to celebrate and explore their feminine powers, lives lived, friendships, and romantic relationships— whether real or imagined. Commercial fabric is her paint, thread is her ink, and the sewing machine her pen.

Kathryn's work has been exhibited nationally and internationally, and has appeared in numerous national and international publications. She was featured on three segments of Quilting Arts TV in 2019 and is the subject of an Artist to Watch interview in Exploring Art Quilts with SAQA: Volume 2, 2021. She is a Juried Artist member of SAQA (Studio Art Quilters Association), has a Certificate in Fashion Design, and has been sewing since she could thread a needle. Kathryn is the coauthor of *Backart — On the Flip Side*.

Visit KathrynPellman.com for information on workshops and lectures, and to see more Fashionistas.

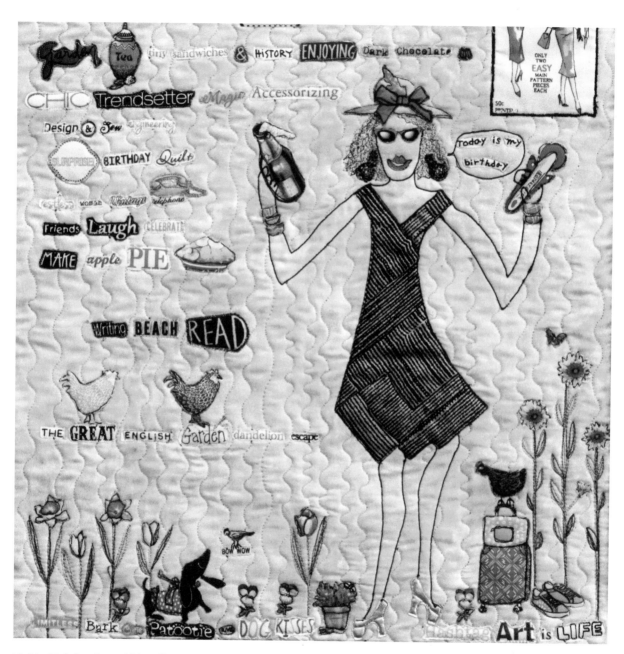

It's My Birthday Again! (detail)

Words to It's My Birthday Again!

K est. February 1955 Inventive ORIGINAL ECLECTIC Creative Fashionista Quilter
Sewing Studio Combines old fashioned Pattern pieces using glue STICK instead of Sewing
CELEBRATE 65 candles! cheers Passport Bon Voyage LAX to London
Travel ADVENTURE JUST ME ADMIT ONE See a Museum exhibit Explore
Garden Tea tiny sandwiches & HISTORY ENJOYING Dark Chocolate
CHIC Trendsetter Magic Accessorizing
Design & Sew engineering
SURPRISE BIRTHDAY Quilt
restless woman Vintage telephone
Friends Laugh CELEBRATE
MAKE apple PIE
Writing BEACH READ
THE GREAT ENGLISH Garden dandelion escape
LIMITLESS Bark Cutie Patootie OLIVE DOG KISSES Hashtag Art is LIFE

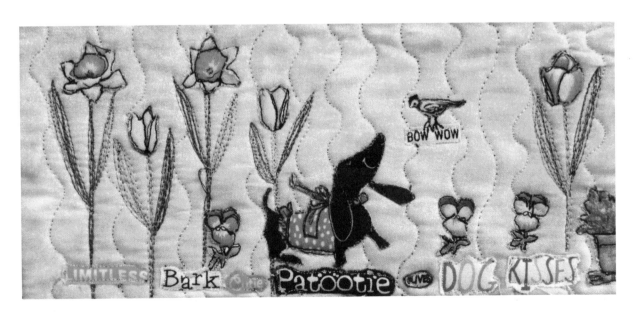

It's My Birthday Again! (detail)

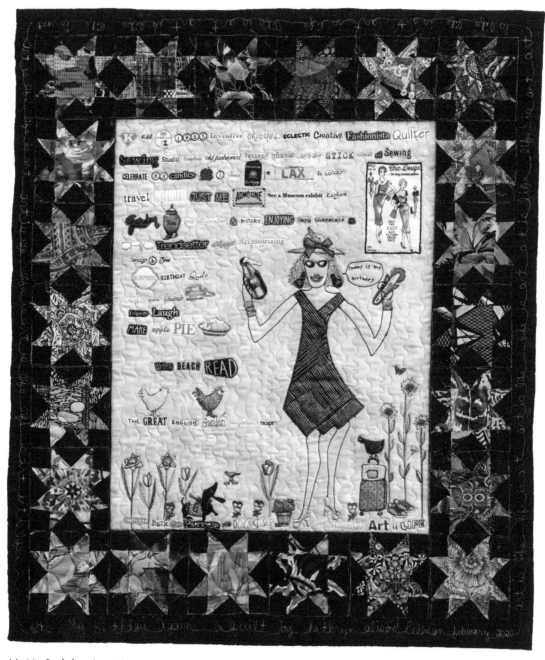

It's My Birthday Again!

24" x 30.25"

Acknowledgements

Thank you to everyone who helped me along the way — Yvonne Bradshaw, girlfriend extraordinaire; Danita Rafalovich, who co-wrote *Backart — On the Flipside* with me; Penny Key who shared many bowls of pineapple fried rice and conversation with me as my thoughts on feminism and fashionistas evolved; Barbara Spielberg, who has some of the original Fashionistas that started out as notecards, for proofreading; Susan Milstein, girlfriend and quilter who loved all my stories, both the good and the bad; Ellen November for her thoughtful feedback; Wayne Smith who took early photos of the Fashionistas in exchange for homemade pie; Mark Kerr and Andrew Pellman for making me rethink some of my book design; Laura Anderson for being an early collector of the Fashionistas; Lisa Glatt who accidentally introduced me to found poems in a poetry writing class at UCLA Extension; Kelly Morgan who had us cut up and rearrange a stream of consciousness we wrote in her workshop where I found myself writing about Willie Nelson and overripe bananas in the same poem; Lissa Auciello-Brogan, my book designer; and everyone who reviewed my book in various stages of completion. If you are not named here, please trust that I have not forgotten you.

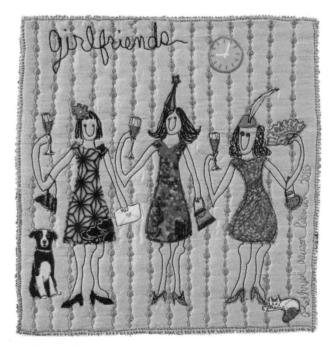

Girlfriends Wine Tasting 8" x 8"

CPSIA information can be obtained
at www.ICGtesting.com
Printed in the USA
BVHW022108100921
616514BV00003B/12